To The Depth oF Love

Lindry Belamour

Copyright ©2014 by Lindry. Belamour

All rights reserved®

No portion of this book may be reproduced, stored in a retrieval system, or transmitted in any form except for brief quotations in printed reviews without the prior permission of the author.

2014 Printing

This book is a work of fictional tale inspired by true feeling and even of my life Where I have to put this feeling in writing. Therefore Names, characters, Place and incidents either are produce of the author's imagination. Any resemblance is entirely coincidental.

ISBN- 13: 978-1478276616
ISBN-10: 14782776614

DEDICATION

Azariah Emily and Emeralda Rose.

CONTENTS

 Acknowledgments I

Chapter One: 1

1. Why Am I attracted to you
2. The proposal
3. To the depth of love
4. Musical of love
5. Word is not enough

Chapter Two: Page 9

1. To the One I Love

Chapter Three Page 19

1. The Feel of you
2. I keep On Dreaming
3. I will keep trying
4. E-Love Do you remember?

Chapter Four: Page 26

1. Little Did I Know
2. The Perfect Season
3. A Strong Feeling
4. My sweet Honey
5. What do you mean to Me
6. My Love, My Life
7. From Now One

Chapter Five Page 36

1. Ma Douce Etoile Du Matin
2. Du Pont D'amour

To The Depth Of Love

 3. Ose De Te Dire
 4. Reve D'etre Avec Toi
 5. Toi Mon Existance
 6. L'attend de M'aime

Chapter Six Page 42

 1. Do You Really Know
 2. Dedication

Chapter Seven Page 46

 1. Do You Remember
 2. Until There Was You
 3. You Are The Love Of My life
 4. The Feel Of You

Chapter Eight Page 52

 1. Confiance et The L'armour
 2. Un Terrain D'armour
 3. De Temps a I'autre

Chapter Nine Page 59

 1. Reason to love
 2. Thank you for the love we share

Chapter Ten Page 63

 1. Raison de vivre
 2. L'amour impossible
 3. L,amie que J'aime
 4. Que tu sois Heureux

Chapter Eleven Page 74

1. Remerciement
2. Profond Regret
3. Valse D'amour

Chapter Twelve Page 84

1. I am thinking of you
2. You stole my heart
3. L'amie que J'aime
4. Que tu sois Heureux

CHAPTER ONE

Why am I attracted to you

Why am I attracted to you?
It's how you make me feel so true.
You make my blood burn with fire.
My feelings run wild with you, such pleasure, such desire!

I remember every moment we share.
No matter how insignificant it may seem, I still care.
When I am down, you lift me up.
You teach me to never give up.

When I look within your eyes, your
penetrating glaze is so strong.
It's as though I look at the sun too long.
I close my eyes, and see you again.
I see the way you move, smile, and the places
you've been.

I am in orbit around you,
suspended weightless as I look at your eyes so
true.
The sound of your voice sends me in a
delirious high,
my head spinning as though I could fly.

I am and always will be the one that loves you
without limits.
I anticipate your touch, such passion in it.
I have breathed you in and need you with me.
I tremble, the thought of you sharing
moments with me.

I dream of you beneath me and above me,
such a pleasurable treasure.
No one else to you can measure.
Make all my blackness goes away from me
tonight.
Allow you and I to be connected by a tunnel
of light.

....and I will,
....forever love you.

Even in the blackest night,
love still lives, and will see me through

The Proposal

My dearest love, to you I write
I've not found you yet, but one day I might
This letter is to tell you, of... the love I hold
for you, and the many different ways, in
which... I'll try to show I do.
I'll love you like no other, I'll hold your heart;
with care. I promise, through all your troubled
times, I always will be there, I'll stand tall right
beside you, you'll never be alone. In my arms,
you'll feel safe, and, my heart will never roam
Faithfully; I'll love you, no other woman could
compare when it comes to my love for you,
When we have a problem, or simply disagree
I'll listen to your opinion, that's how my love
will be I'll never ask of you, what I'm not
willing to do I'll place your needs, before
mine, that's how; I will love you and I'll never

disrespect you, your honor I'll hold up high
Never once, in my life, to you, I'll ever lie
I'll share with you my secrets; I'll tell you all
my fears because of what we have together,
you'll even see my tears, I'll kiss you hard, I'll
kiss you soft I'll kiss you with such passion,
you'll; walk in the air! Fairytale stories, you'll
see, are true You'll be the Queen; my love... is
devoted to! I'll try to be, the best lover you've
had And, still show you, my inner lad.
In your eyes, I'll always see Love so pure, you
have for me I see myself old, with hair all grey
Still loving you like, it's our; first day Holding
hands or, arms to waist Walking together, at a
slower pace One day, you'll read these words
I wrote At least my love, that; is my hope
You will know, when you do I wrote this
letter, just for you.

With a love, that knows no bounds,
Lovingly yours, your one true love

To The Depth of Love:

To see, to die: and always someone at your side, To care and share as someone else envy's your stare. Rage a love begins to fade into the abyss of death; Declining your eyes to see what love was, and allowing you to see what hate is.

… Is what man desire within?
Or is it merely a thought that so lays under God's sins." Sour sun' why is your stare so raging, and along, And 'why' has the night cease with its petal like a thoughts
Those shine through as darkness covers the rest of my soul.

Burning of passion life began,
No one knows what is you or what is me,
But something taken for granted has arisen;
From the depth of love where my life began,
I see terror that only "God" can describe.

Vibrations of love turn to hate
As the sun lowers it's punishing tentacles towards The horizon, and far beyond the light dims I saw Someone else's love turns to slim and drowning deep, Deep into the depth of love's obsessive sea.

Lindry Belamour

Musical Of Love

A little lover's waltz,
Play it for me once more.
I want to listen to it a little more
As if for the first time.
And if you like this melody,
Dance, or sing!
You'll rediscover all the magic
Of the summer's little dances.
And soon musicians, balladeers, and poets
Will tell you, oh, how much they love your
song. The accordion, mischievous in a bit of
madness, will replay this melody without end,
clear as crystal.
And when we are alone we are one
Just you and I, hold me tight
We will always be this much in love,
Listen, it's marvelous, this romance is just like
a confession, remember how often
You'll want it, and you'll sing it again--
The Lover's Waltz! The musicians are here for
nothing, but they make me shiver each time
They play this waltz so gracefully.
I could listen to it until tomorrow.

Word is not enough

There're no words to convey, no words to say. This feeling inside that I have for you, deep in my heart. You can see I'm losing control thinking I had a hold, but with feelings this strong I'm no longer the master of my emotions! I remember the first time I saw you took your coat off and stood in the rain, you're always crazy like that, you're always the mysterious one with brown eyes and care-less words; you were fashionably sensitive but too cool to care. Well in case you failed to notice, in case you failed to see, this is my heart bleeding before you, this is me down on my knees, these foolish games are tearing me apart. Your always brilliant in the morning, drinking you coffee and talking, then you walked out on me, as if I had said or do something wrong! Well excuse me because I've mistaken you for somebody else somebody who gives a dam, somebody more like myself. Yes, I may be alone again and there may be emptiness around, but it's either love or hate. I wish there was something I could say or do! But I'd rather walk alone then

chase you around, I'd rather fall myself then let you drag me on down. You are not the one I used to know, not the one I fell in love with, but no matter what, you'll always be the one I love. So please don't let the sun set without you in my arms, don't let me wake up without you in my heart. Forever.....

TO THE ONE I LOVE

Lonely out here
I think of you oh love
To my heart you are so dear
For you are the one I love;
We are distance apart
Helpless at the hands of destiny
At love we never got a real start
It's such a pity;
Busy, busy, busy and busy!
Not that they are like a disease!
Just that I'd have loved to be by your side
In your arms I would like to slide;

But yeah, you are busy on the phone
You've got to learn, that's enough fair
Of that fact I am conscious;
And I am here in Orlando
Braving this heat
And the sun cooking my skin
It's going to be a long wait, I got to be bold;
I'm here studying and learning

Both of us want the best for ourselves
We are conscious of the world, it's true
To the new ills, we got to find the new cure;
It's true I love you a lot
And your place, no one will take
But it's going to be easy, for love's sake;
In love, I have not gone blind
Your love in fact gives me the energy
And courage to optimize the usage of my
mind a will to forge to the better our destiny;
Our destiny and that of others too
For we are conscious of our duty
To all those who to us have been true
Who've paved our path to this imminent
degree;
Our love is strong
Of that I am sure

To The Depth Of Love

It's so sweet this loving bond
To all pain it's the cure;
Unlike others, being distance apart from you
I don't feel the pain

For joy is all that emanates from you
Our mutual trust is what matters main;
I'd have loved to be with you right now
But I am mature enough to understand
There is no answer to this how
It's going to be long before I hold your hand again;
And we have yet to see each other's face
Your love is what matters anyway
I know our future it will trace;
Love, I miss you
And I know you miss me too
I trust your feeling
This feeling of belonging;
Of belonging to each other
For we are both equal
We are each other's life partner
We are both on the same pedestal;
You know that, don't you?
I am sure you do

Love sweetheart, together
We'll change things for the better;
This is real crazy
We were always together
But never realized bound were our destiny
That we loved each other;
It's only now that we are distance apart
That in our heart we feel this pinch
But we won't lend to disarray
In our conviction we won't flinch;
We got a duty
Towards our daughters
And this fight we will win;
We will stand solid
And face this long trial
On that your life you can bid
Being together is written in our fate;
Things are always for the better of man
Is our firm belief
Understand this is all we can
And in our love get some relief;
Get relief while being so distance apart

On sweet day
from a distance I am thinking of you

To The Depth Of Love

Assessing to what extent our love is true;
But in that I got no doubt
You are just so great
That I love you, I want to shout
Telling others how great is my fate;
I love you
I don't know why
I just about you this aura
It gives me the feeling of flying in the sky;
It's just utter bliss
Simply thinking of you
Your presence I do miss
I just want to be with you;
Yes, you are more than my life partner
You are everything to me
Just like moms, brother and little sister
Close to my heart, you are so dear to me;
What can I write more
I don't quite know
I can't write all my feelings till the core
For this letter is not only for show;
There are things meant only to be understood
Things to words you can't confine
Understanding that you are pretty good
My life you do make shine;

I know after our wedding
Life was not perfect
But for you my feeling
Won't change, your joys I won't neglect;
A little paradise
I can't guarantee you
All I can promise, I'll try devise
All means to shower happiness unto you;
We will quarrel
That's almost certain
But till eternity our love shall dwell
I will never leave or forget you;
You might think I am not
But such is not true;

For that's what we verily should fare;
Love with you is different you know
From what the idea I always had
It's better and makes thy heart glow
And I just feel so glad;
Yes, for me every day
that we are apart
In fact, it doesn't have any meaning
I don't want to confine to a mere day all my feeling;

To The Depth Of Love

I don't know what else to write or say
You are just so wonderful, amazingly great
Even with you the fight
Is of joy a large slice;
For they make us smile
And laugh a lot
Happiness it does make file
Of this little twinge, it hides the blot;
Yes, I would like to be yours again
And keep our little family happy
For this day I do pray
I hope it's written in our destiny;
I know I am far from perfect
But you accepted me with all my defect
For that to you and God I am grateful
For the joys you send, so plentiful;
What else can I write
I just don't know quite
All I want to say
Is for your happiness I do pray;
You don't know how I long I keep this
I just love you
And would like to continue of been with you
for eternity
Hope that's your wish to;

My heart shiver
At the thought of yours
It does quiver
At this love of yours;
It's just so great
Whether it's greatness I can reciprocate
I don't know, but I will try my best

It's a real hard test;
I don't want to see a tear
In your loving eyes
It's not words mere
They are not just lies;
This is the wish deep in my heart
That is lots of happiness for you
For verily, you are my heart
And I would like to be with you still;
What wouldn't I give
From your mouth to hear these
From this burden me do relieve
Do tell me such are your wishes too, please;
Life without you will be too hard
Don't break my life in shard;
I know you never will
'Cause you love me too

To The Depth Of Love

My dreams you will fulfill
'Cause you got similar dreams too;
We are made for each other
No doubt about that
We will always be together
No matter others say what;
I love you
And I respect you
You don't know how I would relish
To fulfill all your wish;
Just be mine
And life will be fine
And we will be happy for life;
For the time being

On our studies let's concentrate
That's better for our well-being
And before Almighty God let's prostrate;
We owe our friends and our daughters a lot
For what we are today
They will be proud of us someday
I love you dear
Although it might seem queer
But I know my love is sincere
And I got nothing to fear;

To end, let me share with you
This feeling from my heart
I really love you
It's beyond me, you are just such a sweetheart!

CHAPTER THREE

My dearest darling,
for you who have taken my heart so
effortlessly, a small poem as token of my love
for you ...

The feel of you!

Sitting in this office, here all alone,
My mind keeps drifting towards my heart…
And my heart… has long left me to be closer
to you.

And here I am, all alone between these 4 walls
a ceiling and a floor,
With my body is here,
And my mind around you…
My smiles for is here
And my thoughts are for you…
With my tough exterior facing here
Keeping all my gentleness and affection for
you!

You keep strolling in front of me
With your wonderful blue and white dress
Flowing around you…
Flowing around you like
A wonderful garden is being blown over
By a gentle breeze,
Showering your perfume around…
Your sweet fragrance which cannot be
matched not even by a thousand fresh roses.

One sweeping glance from you
And my heart skips a beat,
One smile from you and
I feel ten feet taller…
What can I tell you more,

except that I love you…
And that you're very dear to me.

I Keep on Dreaming

My sweet darling,
This is a small poem which I wrote in one moment of despair... when I felt lonely and when I was praying for the coming of someone as wonderful as you in my life...

I keep on dreaming …
'because a dream is a wish that the heart makes when you're fast asleep!

I keep on dreaming… Dreaming of a better life,
A life with someone dear next to me
A life with someone who will hold my hand
And walk along with me.

Will that only remain a dream?
I'm afraid to think about it…
'Cause I know the answer is "yes"!
Life is so hard…
And it has so many times played pranks on me…
Making me fall for the wrong people…
And then punishing me harshly for having fallen.

I keep on dreaming…Dreaming of sharing

my life, my contained love and affection and faith with someone dear, with someone in front of whom I would not be afraid to let down my mask And be vulnerable and human, With someone who would love me For what I really am, and not what I pretend to be, With someone special who would love me Just like I'd love her ...
With my heart, with my mind, with my soul.

I keep on dreaming... Dreaming of sharing my life, with that special girl...
That special girl who would one day
Smile lovingly at me, hold up her hand and say "Come, your loneliness is over...
I'm here now, and you can count on me
Just like I know I can count on you,
At every step of my life "

I will keep trying

I have tried; I have tried to run away from you. I have tried to shatter a friendship and love I hold and tried to dissolve a bond that my past has carried. I have given great effort to unravel the vine. I have taken each leaf of our feelings, holding the memories of the good and bad times, and torn them off.

There is only one droopy stem still holding our relation together. The stem, the main root of our love has been tackled many times by many people. Hurtful things have been said and done, but the plant keeps on living, putting aside the setbacks and obstacles set for us to overcome.

Our love continues to look down, the leaves tearing, the stem looking weary. The plant stands alone, looking for its other half. Yet, even though it is alone and weeping it does not give up on its partner, it just faces the reality of each day, holding himself together and being strong.

Maybe tomorrow, or maybe the next year... When this day comes rolling in, your smile will stretch. You will rejoice and feel a glow of happiness come over you. The leaves will sprout and the roots will thicken, only to ravel up once again the love, peace, and memories our relation once carried. The plant will feel whole again.
Please know that you will always be dear to me.

E-Love.. do you remember these words?

It's impossible to capture in words what u mean to me..You are so special to me, so special to my heart

Spending the whole day chatting and texting we discovered love, a love in it's purest form. When I try to tell you that "I Love You", The words do not even touch the depth of my feelings... but yet I love you

If you were here I'd say thank you for letting me know you, and thank you for knowing me..
But since we are apart I'll think of You softly and love you in my dreams....

CHAPTER FOUR

Little did I know

To my wife... since our wedding is in October 1999! On that romantic day, a small poem for you ...

Little did I know

Little did I know how much I would really

miss you,
Now that we are so so far apart...
Little did I know your value and warmth when
Side by side we use to go roaming around,
Talking to each other, with that special language...
That language which our eyes had slowly made up...
Where no words were needed...
Where every feeling was felt and shared...
When an eyelid flutter meant comprehension...
And the love in your eyes
Would flow towards me like a fresh and bubbly river;
the luxurious garden of your hair,
Like a mantle of deep rich forests along its banks.

Little did I know how much I would really miss you,
Now that we are so so far apart...
But still, the sweet remembrance of your sunny smile,
The crystalline nature of your voice,
The soothing effect of your eyes
Are so fresh and appeasing that
the distance between us becomes ...

insignificant,
As no void would dare to keep our thoughts and feelings apart.

Little did I know the might of love,
Little did I know the height of faith,
Till I meet you,
Till I love you…

The Perfect Season

How surprised was I, when I check my phone, I found a message addressed to me. Yes me!!! This is amazing and yet so cute. Can somebody remain icy after reading such a sweet message addressed to him? So here I am, both leaving a love message for the love of my life and at the same time answering to her demand.

Love, I've spent my life waiting to see
If the one I could love was looking for me.
Then I found you, so precious and true,
Now my life has meaning and reason thanks to you.
You my sweet came in the perfect season.
The season of love for which you came forth,
So precious and true.
I can do nothing but love you.

The minute that I saw you I just seemed to know I began to like you more as our friendship started to grow. People say that it strikes you, like a lightning bolt from above then it turned from like, and now I know that it is love.

I don't know how to describe just how I feel all I know is that it is not "puppy love", it's for real. My head feels like it is spinning around and every time I walk, I feel like I am floating over the ground.

When I stare into your eyes, I know that it is true that you really mean it when you say "I Love You". I wonder how love happens and gets to be the whole thing seems like one big mystery.

But in my heart I know the real reason is because God sent down an angel to bless the two of us.

I now know that you and I will always be together because, I'll love you always and forever.

A strong Feeling

This feeling of love that I have for you,
A feeling so strong, so special, so new.
You give me the gift of happiness each day,
Never have I known it could be this way.
You have given your love regardless of cost,
With my heart in your care, I will never be lost.
Or never again wonder what love really means, for now I do know it means so many things.
Understanding and caring through good times and bad, sharing emotions should they be happy or sad.
Being there for each other through laughter or tears, at each other's side for the rest of our years.
My only wish were to be with you my love,
For each day I pray to the heavens above.
That you always remember my feelings for

you.
A feeling so strong, so special, so new. I may not always be able to find the words to tell you how much I Love You......but I hope I show you, with every look, with every touch, how much you mean to me.
from I to my lovely princess

My sweet little honey

It's late at night as I look to the sky
A million stars twinkling at me
Watching this scene I let out a sigh
'Cause it's your loveliness that I see

Whenever my eyes look upon such a sight
I instantly have you on my mind
My love for you in my heart glows so bright
You're the sweetest girl I'll ever find

I hold you in such high regard honey
Admiring your character so grand
A dignified lady who always shows me
Your gentle and supportive hand

The chills that I get when thinking of you

Are overpowering and make me weak
Precious memories abound, all so true
It's your tender mercies I seek

So baby I guess I am trying to say
I treasure you and always will care
My heart is yours now and will forever stay
With you and your presence so rare

O, never say that I was false of heart, I will love you forever and ever. Dye in your arms and find my wrestling place in your eyes......

What do you mean to me

As I put my pen to paper I think of all the special moments we have spent together, all the little things you did to make me feel special.
I would like to tell you from the bottom of my heart what you mean to me!!
When I think back to my dreams as a little boy, I realize today that my dreams were not far from being an illusion.
You have made my dreams come true, all that I have ever wanted is to be loved, cared for and most of all Happy!!

I was an empty plate that needed to be filled.
Your love in my plate has made my joy
blossom. You always seem to know what
would make me happy, your little notes &
messages brighten up my days, making me
look forward to what tomorrow holds.
You have been my pillar of strength through
difficult times and my best friend when I
needed to talk.
These little things I will never forget and that
is why I will always LOVE YOU!!!

My Love, My Life

I liked you the first time I saw you
I loved you the first time I met you
Love came so unexpectedly
And that's what makes its beauty
I'm listening only to my heart
Leaving the rest to GOD's will
Somehow I know we had to meet
And make this journey together

So far from each other
Yet so near in each others' heart
All obstacles are surmountable
As long as we face them together
Never tired to say
I'll love you forever

My love, my life
You are always in my heart
In my thoughts and in my plans

Until we meet again
Take care and remember
Our love is true
True enough to be strong
Our love is strong
Strong enough to face time

From Now On

To My love, I will love you with every beat of my heart I will always be there, always cherish you From now on, my life begins From now on, there is only you ... You're the reason I believe in love You're the answer to all my prayers I'm blessed and live for your happiness For your love, I'd give my last breath ... From now on, I will give you my hand with all of my heart You and I will never part My dreams will be reality because of you... By your side, where I
belong through weakness and strength Happiness and sorrow for better or

worse From now on and as long as I live I will love you now, always and forever....

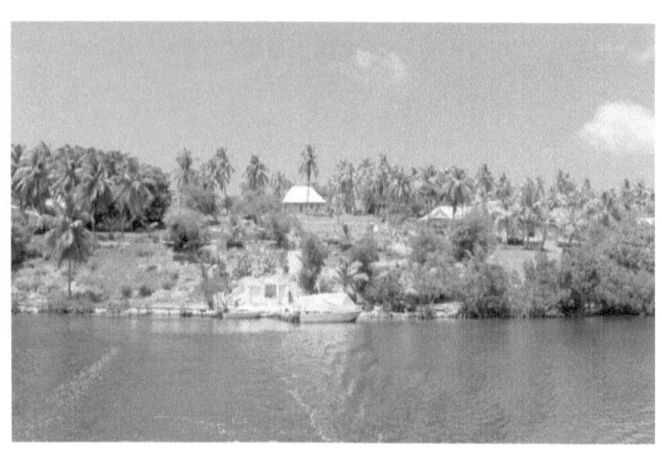

CHAPTER FIVE

Ma Douce Etoile du matin,

Mon Tresor, depuis que tu m'as laissee ici, je ne suis plus la meme, je n'arrtee pas de prier pour ton retour, pour qu'on puisse etre a nouveau ensemble, ton absence me laisse un lent poison dans ma vie, la vie sans toi est tellement cruelle, je ne la supporte plus, quand tu es loin de moi, je deteste tout, je suis loin de tous,
tu es au fond de mon coeur et au creux de

mon ame, tui es tous ce que j'ai le plus cher au monde, Reviends Vite mon doux parfum de paradis,

Du pont d`amour

Du pont de pierre ou le jour se leve dans la brume et s`offre sans pudeur, imagine deux regards qui s`etonnent dans l`indiference des autres; deux mains qui cherchent une porte a ouvrir une chaleur a offrir; deux corps qui s`enlancent et se chantent des caresses jusqu`alors retenues; un cri a l`aube d`une vie, de nos sangs meles une promesse chaque jour renouvelee; nos regards nos mains nos corps, notre amour
Toujours, peut-etre....l`intensite d`un moment present surement!
Je T`aime mon amour, c`est simple, comme le jour!

Ose de te Dire

Des choses que je voudrais te dire A Belarmelle
des choses que je n`arrive pas a dire
des choses que j`essaie de noyer

dans la trame des mots
dans la contradiction
dans la fuite
dans le detour
des choses simples
des choses a la fois profondes et douces
des choses dans facons
des choses que n`importe qui pourrait dire
a condition d`oser
a condition d`essayer
a condition de les dire
des choses qui ont deja ete dites par d`autres a
d`autres
des choses qui ne se disent tout de meme pas
si facilement
parce que rare
parce que secretes
des choses que je voudrais te dire sans avoir a
les dire
parce que c`est deja trop de dire
parce que c`est ne rein dire pour ainsi dire que
de dire ca
parce que c`est au-dela de tout ce qu`on peut
dire
c`est presque ca que je voulais te dire
mais que je n`ai encore pas vraiment su dire
parce que je t`aime
parce que je t`aime toi
parceque c`est ca que je ne peux pas dire

ca que je veux depuis longtemps t`ecrire
ca que n`ayant su dire j`ai quand meme ose dire.

Reve d'etre avec toi

Quand la courbure du temps se referme sur moi, Quand la derniere lueur d'espoir s'estompe comme la fin d'un souffle
J'ouvre mes yeux sur un reve qui flotte et virevolte dans ma tete
Qui m'etreigne et me caresse
C'est le reve d'etre avec toi
Uni pour la vie
De s'echapper au piege du temps
De renaitre et d'insuffler avec chaque regard echange le secret de la vie
De se liberer des contraintes terrestres
Pour mieux s'aimer, pour devenir tous deux...
Un seul etre

Mon amour, cela fait si longtemps que je reve de toi sans oser te declarer ma flamme. Meme si aujourd'hui dans mon coeur je te dedie cette lettre, je sais que je ne te l'enverrai jamais.
Je ne puis te dire combien je t'aime... Je vis au

son de ta voix, je respire au gout de ton parfum, et mes yeux ne voient que ton visage. Un simple sourire de ta part rend ma journee merveilleuse, et au fond de moi je sais que tu es ma raison de vivre.
Mais comment t'avouer mon amour? Etre avec toi, me semble etre une chose impossible, une chose qui n'existe que dans mes reves les plus incenses. Mon amour pour toi continueras d'exister tant que la terre tournera et que les oiseaux chanteront, encore une fois Je t'aime

Toi Mon existance

C'est avec toi que ma vie a vraiment commencée, ton regard de braise à bruler mon coeur.. lors-ce-que tu es là, c'est moi qui n'est plus les pieds sur terre, jamais au grand jamais je ne pourrais imaginer ma vie sans toi.. Mon existence est liée à la tienne pour toujours. Ta marrie qui ne cesse de penser à toi si loin.. et pourtant si proche..

L'attend de M'aime

Quand je t'ai rencontré en novambre de cela dans un festin de marriage.
J'ai eu le coup de foudre et j'ai su à la minute

que j'éprouvais quelque chose pour toi. Je n'ai jamais aimé comme je t'aime
Alors que pour toi, je n'étais qu'une amie
A force d'attendre qu'il y ait plus que de l'amitié,
Je me suis lassée et j'ai pris la décision de m'éloigner de toi afin de t'oublier
Et voilà qu'à l'aube du troisième millenaire, tu me dises que je ne te laisse pas insensible et que pendant ces dix-setp années, tu te sentais bien en ma compagnie et ainsi tu t'es décidé à sortir avec moi.
Aujourd'hui, on est bien ensemble et on s'aime énormément.
maintenan, J'ai passé un bon moment en ta compagnie même si on était les seuls amoureux à fêter, dans un "Curepipe" désert en plein cyclone classe 3.
Dire "Je t'aime" pour toi implique beaucoup de choses que tu n'es pas prêt encore de me dire.
Mon amour, j'attends avec impatience le jour où tu me diras "Je t'aime LB" car moi je sais que je t'aime et que je t'aimerais toujours et je peux même te le dire.

CHAPTER SIX

Do You Really Know how Much You Mean to Me?

Sometimes I wake up in the middle of the night shivering from fright feeling empty feeling nothing because I think about how it would be if you weren't here.
And then I wonder if you really know how very much you mean to me, how incredible I think you are, how you are a part of all my emotions, how you are the deepest meaning in my life.

Please always know that I love you more than anything else in the world.
To end up, I would like all the web-surfers to witness what I'll write next. It's not a joke, my life depends upon it.

I love you. I would like to spend my whole life by your side. So will you …?

Dedication

You walked into my life one beautiful day When I was least expecting you...

Your e-mails, messages, chats and texts messages have been inspiring So much love, care and tenderness... Who would have ever thought that our casual friendship would have one day developed into such a wonderful Complicity of two hearts beating as one... For everything you are... Every feelings and emotions you have brought to life within my heart and soul... There is only a thing I shall tell you... I love you... And always will. My life is dedicated to you.

I'll be with you, no matter what happens to us and between us. If you should become blind tomorrow, I'll be there. If you achieve no success and attain no status in our society, I'll be there. When we argue and are angry, as we inevitably will, I'll work to bring us together. When we seem totally at odds and neither of us is having needs fulfilled, I'll persist to understand and in trying to restore our relationship. When our marriage seems utterly sterile and going nowhere at all, I'll believe that it can work and I'll want it to work and I'll do my part to make it work. And when all is wonderful and we are happy, I'll rejoice over our life together, and continue to strive to keep our relationship growing and strong

This life is made to be with you, to be by your side every night and every day. Because you're so special in your own way that sometimes I even wonder if you're really from this world? Whenever you look at me, your eyes speak it all. And whenever you smile at me, I fall out of my senses. You turn each of my days into

heaven and make my life seem perfect.
It feels so right to be with you, so right to wake up with you in mind and fall asleep at night dreaming of you. You are the mirror of my dreams, the smile reflected in my thoughts. You are the one I've been waiting for all my life!
and I know that this life is made to be with you forever......

You are the reason I survive, because with you by my side, everything has a true meaning. Every day is a special Day and I want to say: I love you always.

CHAPTER SEVEN

Do You Remember

Remember the mountains that stand as long as love exists…
Remember the flowers that bloom like our deep love, Remember the fire that melts our hearts into one; Your touch so mild make me shiver. Your eyes, as bright as the sun, Undress my soul to see the immensity of my love. Remember you and I, Together lying in the midst of the green grasses of the meadow in Lincoln park, Your fondle immersed
Me in a world of fantasy; remember the sweet caress of lips in my neck

To The Depth Of Love

It was so wonderful to be with you
Cause you knew how to awake
My most hidden impulsion;
Remember the moment
When you made the last step…
You possessed my soul
And we were the union of passion…
Now that you're gone with another,
will you share the same passion
We've had together?
will you take hold of with the same fierce
And utmost desire to find the unknown?
Don't you remember our romance till dawn?
Don't you remember me…?

I still remember the first time I saw you
In your eyes I saw lots shinning bright
now that this sound new, I was going to love
you like I never love a woman before
can`t you see this is a love for you and me...

Ever since you walk in to my life my meaning
of life has change I rearrange my entire way of
looking of things and beauty and all that I see
is because of you, is because of my love for
you

You help me find who I am cause I can see
who you are I love you, you are a shinning

star for me in a private galaxy

Until there was you

To the one who gives its meaning to unconditional love, I have searched and searched. I have sat down for hours, thinking, trying to know what it is. I have tried to define it, to ask people what it is, to feel it, to give all I have for it but I never knew what it was until there was you. You did not tell me what it was you did not buy me roses and say I'm you are everything. You did not promise me the world or the moon or say you'd die for me. You were just you. You just stayed there quietly learning everything that makes me. All I have ever thought it was, all I have ever felt it was, I saw it in you, in your every move, your every word. I am still not quite sure how to explain it or if what I feel is it but I know you know it. You are it. In your eyes, I see it; in your tender touch, I feel it; in your sweet kiss, I taste it; in your silent whispers, I hear it and your very scent is full of it. You have no conditions, you are true, pure, innocent...
You are her, you are It, you are True Love.
Learning to Love you.

Hearts and flowers and chocolate and stuff,

Might say I care, but not enough.
Paper hearts get ripped to shreds.
Candy makes your middle spread.
Flowers die before their time,
But the stuff I send is in the rhyme.
Devour these words and you will know,
Sweet Love, I love you so.
For all you've done to show you care,
For everything you've gladly shared,
For all the sweetness in your soul,
I send my thanks so you will know...
That it isn't just on this moment,
You're loved always

YOU'RE THE LOVE OF MY LIFE

With you...
I am who I am and not who
I should be,

With you...
I can hear my silence speak a
thousand words,

With you...
I can spend my life just feeling
your warmth,

With you...

My precious, I know true joy~
I know Love.

Lots of sweet kisses & warm love.
From your sweetheart,

Alone I am Alone

You left me all alone
And I am all by myself
I am starting to weaken
For its been months since you left me
You said you love me
But where are you now
When I need you the most
You the best thing that ever happen to me
But where are you when I am at worst
It is worth calling me bad names
While I am so sad
Night time I lay my bed
I beg to touch your leg
But its only happening in my dreams now
Every little makes me think of you
No matter what I do
My love was true
My love is so real

To The Depth Of Love

I gave you my love
But the very next day you give it away
And you cut my love away from you
Far away from you
And there is no way back to you

CHAPTER EIGHT

CONFIANCE et de L'AMOUR!!!

Tu vois il est tard et je m'ennuie de toi, tu hantes mes pensées et enjolives mes journées. Bientôt ce sera la plus belle jourée au monde, la fête de notre amour. Et moi j'en profite pour laisser mon coeur parler.

Pourquoi? Eh bien je sais pas trop, peut-être parce qu'avec toi je suis si bien! Lorsqu'une simple idée de toi surgit en moi,
je sens un flambeau brûler en moi. Ta présence, ton attention et toute ton affection, te rendent si charmante!!

Je suis heureux de t'avoir connu car depuis
cette soirée, en moi un grand vide a été
comblé. Tout l'affection et la confiance que
j'ai tant cherchée c'est enfin au près de toi que
je l'ai trouvée. Ton regard, tes tendresses, ton
soutien et ta douceur, font que pour la
première fois, je me sens bien et en confiance.

Avec toi "mon armour",
J'affronterai des océans affolés
Les pires cauchemars à inventer
J'effacerai mes peurs du passé
Avec toi je veux tout partager
Je veux être vrai et passionné
Et c'est à toi que je veux confier,
Mon petit coeur affolé,
Ainsi que tout L'AMOUR que J'ai,
a te confier

C'est sûr, ces quelques vers que je tiens en
cette merveilleuse occasion de notre
aniversaire sont pour te dire à quel point je
tiens à toi et combien je suis heureux de
t'avoir près de moi.

Notre chemin sur les sentiers de l'amour est
peut-être tout récent, mais à la fois si joyeux et
apaisant. Tout doucement je sens en nous

gravir un lien merveilleux; celui de la
CONFIANCE et de L'AMOUR!!!

Un terrain D'amour

Pour la rosée qui tremble
Au calice des fleurs
De n'être pas aimée
Et ressemble à ton coeur
JE T'AIME

Pour le doigt de la pluie
Au claverin de l'étang
Jouant page de lune
Et ressemble à ton chant
JE T'AIME

Pour l'aube qui balance
Sur le fil d'horizon
Lumineuse et fragile
Et ressemble à ton front
JE T'AIME

Pour l'aurore légère

Qu'un oiseau fait frémir
En la battant de l'aile
Et ressemble à ton rire
JE T'AIME

Pour le jour qui se lève
Et dentelle le bois
Au point de la lumière
Et ressemble à ta joie
JE T'AIME

Pour le jour qui revient
D'une nuit sans amour
Et ressemble déjà
Ressemble à ton retour
JE T'AIME

Pour la porte qui s'ouvre
pour le cri qui jaillit
Ensemble de deux coeurs
Et ressemble à ce cri
JE T'AIME
JE T'AIME
Je t'embrasse très fort, mon amour.
De celle qui t'aimera toujours.

De temps à l'autre

Je pense à la façon dont je voudrais que soient les choses pour toi ...
Sais tu ce que j'aimerais qu'il t'arrive?
Je voudrais que tu sois plus heureux que tu ne l'as jamais été de ta vie
Et j'aimerais tellement qu'enfin se réalisent pour toi ...
tes projets, tes espoirs et tes rêves,
Et bien tu sais, un jour, cela se produira
Parce que tu fais tout ce qu'il faut
Parce que tu mérites d'atteindre les sommets vers lesquels tu t'élances et parce que tu es exceptionnel.
Pas un jour s'écoulera sans que mes voeux ne t'accompagnent Merci d'être un femme si bonne, si estimable et si merveilleuse, Je me suis laissé pieger. Piegé dans la plus grande prison jamais existée. Meme Dieu a pus avoir ses evades mais moi je suis emprisoné a jamais. Emprisoné a cause de Cupidon. Dieu ta cree a son image, a celle d'une vrai deesse.

Tu est mon envie, ma passion. Ta voix

me frissone, tes levres sont aussi doux que le miel et tes baisers me mets dans un etat paralytique. Ton corp est modelé a la perfection, nul besoin de chirurgie esthetique. J'espere que je serais a la hauteur de tes esperances J'espere que notre amour n'aura pas de fin. J'espere que tu est la personne qui sera devant l'autel avec moi …. je le pense vraiment. Je t'aime.

Reussite

La reussite n'est pas visible
Sa nessesite de toi de la rendre visible
Si elle resite
Il faut persister
Pour tout les temps
Ettends toi cherche ta proper voi selon ta loi
Fais tes choix avant d'etre sur la croix
Crois moi il sera trop tard
Car tu ne pourra pas etre resesuter
Car tout les peche que tu as commis
Tu le les aient pas encore confesser
Mais vaut mieux tard que jamais
Alors met toi a genoux devant DIEU
Et pardonne toi
Car tu vaut mieux et avec l'aide de DIEU

Et tu verra tout tu ira mieux
Donc arête de suivre ses vieux
Qui te font marcher sur des faux pied
Met toi a l'ecart et cherche les pieux.
Il croivent en celui qui est aux cieux

CHAPTER NINE

Reason To Love

The time has come to tell you exactly how I
feel, And I pray that you will know this love is
very real. I love you for all your loving ways,
And for bringing happiness to each and every
day. You are my angel in mortal skin,
Who's opened up his heart and let me in.
I love you when you're very near,
And because when I'm with you I have no
fear. But wait, there's more I want to say,
I love you more with each passing day.
I love you when you're very far,
And just for being exactly who you are.
The list is not over, it's not quiet through,

There are more reasons why I love you.
I love you for all you always do,
And for coming in my life right on cue.
I've searched the whole world over and never
thought I'd find a woman so warm and loving,
gentle, true, and kind, I love you for your
warm embrace, And how your smile lights up
your face. I wanted to know without a doubt,
Before I let this secret out.
I love you for how you make me feel,
And for showing me that love is real.
Upon a falling star I make this vow,
To love you unconditionally, this I shall.

Well this letter may come to you as a
complete surprise, but u must believe me
when I say that it was not of a sudden urge
that has prompted me to write to you. I've
would have done so much before, but lack of
confidence prevented me from doing so.

When I first saw you I was so attracted by
your sweetness of speech, simplicity and
manners that it became difficult for me to
shut you out of my mind. The more I tried to
forget about you the more I began to think of
you that it dawned upon me that I had fallen

in Love with you.

Though we have seen each other so many times, I have never felt confident enough to confess my love to you, thinking that if you reject me I will be the saddest person.

Believe me I have suffered in silence being uncertain about your feelings towards me. I asked myself if you have ever though thought of falling in love with me. So please let me know about your feelings towards me as soon as possible so that I may not be under any illusions of my mind.

Well to end this letter... let me tell u that...

You know It started with friendship And that was all it was to be but then after a while it was much more than a smile,
I can feel my heart beating Shouting out for your name. I couldn't stop shaking and being around you is not the same.

I tried to hide my emotions tried hard not to

let it show even so, I want you to know Just
how much I love you so

Thank you for the love we share

Darling I want you to know that the kind of
love we,

It share must be one in a million.

THANKS for the friendly love--
the smile across the room,
the feel of your hand in mine,
the music of your heartbeat next to my heart

THANKS for the caring love--
the love that gets me through,
the love that shares, the love that helps.....

THANKS for the passionate love--
the love that lets hours pass like minutes,
the love that locks out the world,
the love that I know will always be mine.
Today I just want to say thanks for all the
kinds of love we share.

CHAPTER TEN

Raison de Vivre

Mon amour, cela fera bientot 14 ans
que nous nous aimons toujours autant.
Je n'aurai jamais penser
qu'entre nous ca aurai autant marcher,
mais tu m'as prouvais le contraire,
tu m'as prouvais qu'on pouvai le faire.
La fin du monde,moi je la vois juste sans toi,
toi ma raison de vivre,
toi mon roman , toi mon livre.
Il ne me plus reste qu'a esperer,
qu'un jour je serais ta destinee.
Ne me quittes jamais, car pour toujours je

pleurerais.
Saches vraiment la sinceritee de mes sentiments.
Je te loue, mon amour, parceque tu nous aimes:
Tu es la meilleure de tous les amis,
mon armour
Tu ne m'abamdonnes jamais et tu pardonnes
Toutes mes mauvaises action;
tu es toujours la, a me soutenir, dans mes moments difficiles.
J'aurais voulu etre toujours plus comme toi. Je t'aime.

L'amour Impossible

Bien des fois nous nous disputons, pour la bonne et simple raison que nous deux c'est quasiment impossible. Je vis deja avec elle, et c'est difficile a accepter pour toi je le sais. Mais que faire quand on est eperdument amoureuse d'une personne mais qu'on peut rien y faire et en meme temps etre bien avec une autre, sans pour autant l'en aimer follement.

Je m'excuses les mots sont trop difficiles et ne

viennent pas facilement. Je t'aime! est - ce mal que de t'aimer, l'amour n'est - ce pas le plus beau sur cette terre. Je ne peux passer une journee sans que mes pensees ne viennent vers toi.

L'envie de carresser ton corps, de te faire l'amour et d'etre enfin vraiment moi, me tourmente mais Je ne peux pas, j'ai peur des consequences.

Mon amour, si simplement je pouvais tout recommencer, je ne sais pas peut etre que je t'aurais choisi ou peut etre pas.

Pardonnes moi, si parfois je ne sais te dire mon amour, mais je ne suis pas tres expressive, alors je me caches derriere d'autres jeux de mots.
Je te laisse de la plume mais pas de la pensee..

L'ami que j'aime

Tout a commence il y a une dix-sept ans quand je t'ai rencontre a l'intermediare de ma soeur. C'est vrai, tout parait immoral, insolite... mais pourtant je l'ai fait. Je t'ai envoye un message sur ton e-mail pour

etre plus sure. Mais voila, tu fuis... tu me fuis.
Quand je te parle au telephone, essaies-tu de me comprendre? Sais-tu que je meurs d'envie d'etre a tes cotes? Sais-tu que je t'aime? Me vois-tu? Ressens-tu ma presence? M'entends-tu d'etre la personne en qui tu as besoin? Quand je t'envois un message, sais-tu vraiment qui je suis?

Mon coeur ne bat que pour toi,
Chaque seconde que je passe avec toi
Est un vrai bonheur pour moi.
Tu es ma source
De bonheur et d'espérances,
A mes yeux,
Rien n'est plus doux que de sentir
La chaleur de ta peau contre la mienne.
Tu n'as point besoin d'être
Quelqu'un d'autre pour que je t'aime,
Je t'aime comme tu es,
Tu es mon rayon de soleil
Qui illumine mes matins et

Remets un peu de chaleur
Dans ma vie.
Toi seul a su perçer le secret de mon coeur
Et d'y enlever ce bouclier.
Pour tout le bien que tu m'apportes,
Je te remercie et je te dis "je t'aime"

Que Tu sois heureux

Il ne se passe pas une minute sans que je pense à toi. Pourtant, je sais que rien ne se passera entre nous. Ton coeur est promis à une autre et cette autre personne te rend très heureux. Je n'ai jamais déclaré ma flamme pour toi par peur que tu me rejettes. Je préfère t'aimer en silence. Cela me suffit de te voir heureux. Si c'est cela le seul bonheur que je peux ressentir en t'aimant, c'est déjà beaucoup et j'en remercie Dieu. Aussi chèr que mon secret puisse être et aussi grande que ma souffrance puisse être, j'ai fait pourtant le serment de t'aimer sans espérance mais non sans bonheur. En ce jour de fête, mon

coeur te dit : je t'aime. Sois heureux.

Moments inoubliable

Cela fait bientot 17 ans que l'on se connait et j'ai l'impression de t'avoir tout le temps connut. Oui toute ma vie, Je profite de cette merveilleuse fete, fete de notre amour pour te dire que je tiens beaucoup a toi, tu es ce qui m'es arrive de plus pure, de plus simple et de plus extraordinaire. Merci de m'aimer autant que tu me l'as demontre et sache que je t'aime du plus profnd de mon ame. Le fait que maintenant nous n'habitons pas sur le meme toit ne change en rien mon amour pour toi, voila que j'ai t'attendrai pour des annes, je te promets d'etre digne de cette amour que tu m'offre, un amour qui me laisse libre de m'exprimer, de tout te dire et surtout qui grandit chaque jour un peux plus. Meme si l'on n'a pas passe cette fete ensemble, dans mon coeur, j'ai resenti comme un tonnerre qui resonnait en pensant a nos instants fabuleux passes ensemble.

Attends moi mon amour, tu tres importante dans ma vie. N'oublie pas notre secret: "Je t'appatiens et tu m'appartiens."

Aujoud'hui, j'exprime mon amour envers toi et celà en toute confiance, sincérité, dévouement et surtout de l'amour: Je t'aime avec tout mon coeur.

J'ai tout confiance en toi avec l'amour que tu me montres et pour celà je t'aime infiniment. Je t'aime mon amour.

Les Temps Sont Pas Facile

Les temps n'etait pas facile, tout tenait a un bout de fil mais la galere faisait de nous des frères, tu etait comme un frere d'une autre mere, et ton pere etait comme mon pere
On avait toujours de quoi a faire,
On avait toujours de quoi a parle
Meme si les temps n'etait pas facile
Et si il faut dire s'etait la desh
Chaque matin tout fresh

On se demander est ce que cette galere a une
fin. Cette fain d'une meilleurs vie
Me tourmenter jusqua dans reves
Mais quand je me reveille c'est se cauchemar
sans fin. Mais que peut ton faire? les bonnes
choses viennent avec la patience
Nous voila des annees plus tard entrain de
faires des affaires pour nourrir nos familles
Chere Pere que ton nom soit santifier que la
gloire viennent a ceux qui se fie a toi
Me voici a genoux devant toi car j'ai besoin de
toi, Je ne peux plus supporter ce qui est
devant moi. Laisse boire dans ta coupe pour je
piusse voire ce qui est a venire
Pour eviter de trebucher et de tomber sur
mon dos Protege moi car la vie est base de
coup pas Quelque fois trop bas qu'il m'est
impossible de les eviter
Donc je glisse et tombe vaicus mais pas
conquis Physiquement je suis detruit mais
spirituellement Je suis intact
Et avec ma foie en DIEU LE TOUT
PUISSANT Je serai compact
Je sais dout je vient tu met pas sur mon
chemin tu cherche ta fin

Je crois pas que chaque saint toussant ta mere
veuille ceuillir des fleurs
Pour son unique fils tomber dans l'ignorance
en croyant invincible
Voici mon baiser d'adieux ou que tu soit
j'espere tu y seras mieux
Que DIEU benisse nos freres qui glisse dans
le comas sans reveille

Les temps sont pas faciles
Tout tient a bout de fil
Et le temps fil

Ta niece je la protegerai comme ma fille
Ta femme je l'ai traiterai comme ma mere
Ce n'est pas la mer a boire
Mais un homme doit etre a la hautuerde ses
responsalites
Ne pas montre de desabilites
Et le courage doit habiter
Dans son Coeur pour empeche les moeurs
Qui cherche a nous torturer et a nous couper
notre soufflé
Alors que nos bougie sont toujours avec plein
de soufle

Les temps sont pas facile
Tout tient a un bout de fil
Et le temps fil

Je souhaite avoir contribuer a la caisse d'epargne
Ca m'aurai epargnier beaucoup de conflit ecrit ou verbal
La vie est une canibale
Elle te mangera tout crut

CHAPTER ELEVEN

Remerciement

Je tiens à te remercier pour tous les bons moments partagés avec toi. Avec toi les choses sont différentes et surtout j'ai une bonne raison d'exister. Je t'aime comme je n'ai jamais aimé. J'ai besoin de toi et de ta chaleur pour subsister malgré que des fois entrenous les idées sont antinonies. Aujourd'hui, plus que le jour où je t'ai connu, j'ai besoin de toi pour vivre. Pardonne mes caprices et mon caractère,

pardonne moi surtout si je t'aime trop. J'espère que ce petit mot te plaira . N'oublie pas que quoi qu'il arrive, Je t'aime et je me réveille tous les jours avec joie car je sais que quelque part toi, tu m'aime sincèrement.

Tout nous separai, je suis un homme, et toi une femme, nous venons de familles differantes, nous n'avions pas les memes amis, et allions a des ecoles differantes et pourtant un jour un regard s'est accroche et depuis nous avons uni nos vies. Cela fera bientot 12 ans depuis nous avons tout partage et nous pensons que rien ne pourra plus nous separer.

Je voudrai en ce jour de te dire merci. Merci d'avoir cru en notre amour. Merci pour tout ce bonheur. Merci pour l'enfants que tu m'a fait. Merci pour savoir endurer mes mauvaises humeur. Merci de partager mes joies et mes peines. Merci de partager ma vie. Tu n'est pas ma moitiee mais mon tout.

Sans toi je ne suis rien. Aujourd'hui tu vis en moi et t'enlever de moi serai m'enlever la vie. Toutes les lettres del'alphabet ne suffisent pas a ecrire tout ce que je voudrai te dire. Mais si Je devais resumer mes sentiments pour toi ils tiendraient dans ces mots magiques Je t'aime.

Je t'écris pour te déclarer ces sentiments que je garde en moi depuis tellement longtemps.
Mais maintenent je n'arrive plus a les retenir tellement ils sont forts.
Je n'ai jamais ose te les dire avant parceque j'avais peur de ta réaction, peur aussi que tu me repousses. Le fait de te voir a toujours et continuera a me rendre fou.
Déja que maintenant je sais que je ne te reverrai plus.
Je sais que l'occasion s'est presentee a moi plusieurs fois pour te dire que je t'aime mais c'est en partie a cause de cette fichue timidite et ce manque de confiance

que j'ai. Il y a des millions de facons d'aimer, mais moi je t'aime et je t'aimerais de la plus simple et la plus belle facon; je t'aime avec mon coeur. J'espere qu'un jour que toi aussi tu me diras "je t'aime" Quoiqu'il en soit tu es et resteras la plus belle et mysterieuse fleur qui egaillera mon coeur.

Esperant te revoir un jour pour t'offrir encore mon amour,

Profond Regret

Salut ma belle, cela fait deja des mois depuis la derniere fois qu'on s'est parle...tu etais si content de m'entendre, si content que j'ai pas eu le courage de t'avouer que je t'aime pas. Tu penses surement que je t'avais menti en te disant que j'aime quelqu'un d'autre et pourtant c'est la verite. Tu es de plus deja la femme d'une autre homme...c'etait pour me venger d'il que je suis sortie avec toi, mais maintenant je le regrette amerement - parce que maintenant je suis en train de vivre l'amour de ma vie avec la femme que j'aime (et qui m'aime!) et c'est seulement maintenant que je realise a quel point que ce que j'ai fait est mal. Je suis vraiment desolee, pour toi et pour ton marie... Esperant qu'un jour vous arriverez a me pardonner...

<div align="center">*******</div>

Mon cheri, Je voudrais te dédier ces

quelques lignes pour te dire combien je t'aime et combien je pense à toi nuit et jour. Peut-etre le mot "amour" n'a rien de spécial mais pour moi si. Comme Je voudrais te le dire et le dire!!!!!!!

Mais je crois que jamais ça ne marchera entre nous. Tu es celui que j'ai toujours réver d'avoir à mes cotés pour toute ma vie. Je t'attendrais mais pour combien de temps si toi-même tu ne m'accepteras jamais dans ta vie.

Valse D'amour

Une petite valse d'amoureux,
Rejouez-la-moi encore une fois--
Je voudrais l'écouter encore un peu
Comme pour la première fois.
Et si vous aimez cette melodie,
Allons danser! ou bien chantez!
Vous retrouverez toute la magie
Des petits bals de l'été

Et bientôt musiciens, balladins et poètes
Vous diront, oh, combien ils aiment votre chanson.
L'accordéon bien malin dans un brin de folie
Rejouera cristalin sans arrêt cette melodie
Et quand nous ne serons rien que nous deux,
Que toi et moi, embrasse-moi.
Nous serons toujours aussi amoureux,
Ecoute, c'est merveilleux.
Cette roman c'est tout comme un avoeu.
Rappele-toi que bien des fois
Tu le voudras et tu rechanteras--
La valse des amoureux!
Les musiciens n'y sont pour rien,
Mais ils me font frissonner chaque fois
Qu'ils jouent cette valse en toute grâce;
Je pourrais l'écouter jusqu'à demain.

Mon amour, chaque matin lorsque je me réveille, j'entends ta voix qui me dit : JE T'AIME. Pendant la journée, peu importe qu'elle soit bonne ou mauvaise, c'est ton

visage qui me hante, et ce bonheur-là, personne ne peut me le prendre. Le soir, lorsque je vais dormir sous le regard de ces étoiles qui illuminent ma chambre, je me sens heureuse...Heureuse parceque je sais que toi aussi tu t'endors sous ce même ciel étoilé et que toi aussi tu penses à moi. Tout en fermant les yeux et tout en voyant peu à peu disparaitre ton si merveilleux visage, je te dis: JE T'AIME. A DEMAIN MON AMOUR.

Love Qu'il soit rempli de belles surprises Ou qu'il traverse des temps de crises Un amour aussi beau que le notre Ne peut se comparer à aucun autre JE T'AIME

CHAPTER TWELVE

I am thinking of you

To write a love letter. This sounds easy but when you get started with your pen and paper in hand, it seems that it is hard to put your feelings into words.

How many writers, poets, artists have tried to describe love? "Love is a wonderful thing" would say singer Michael Bolton and yes he is right. It is indeed a wonderful thing but damn, it is so hard to find words strong enough to describe your true inner feelings for someone.

I seize this opportunity to send a message of

love to my beloved one, Love.
Of course, these are only words and the best thing I can do is to prove her my love each and every day.
How are you? Hope that you are fine and that life is smiling at you. I'm writing this letter to you because there are so many things I want to tell you, but which I can never utter in your presence.

Love, since the very first time I saw you, I knew that I had lost my heart. It had left me to stay with you forever. Here, my life is so lonely and miserable, and you are so far away from me that life has become unbearable.

Each time I close my eyes, I see your sweet smile flashing at me. I try to get up, and your superb eyebrows, encouraging me to lie down. I try to speak, and your smooth twinkling eyes force me to silence. I switch off the light, and yet the aura of your presence brings sunshine in my life.

Dearest Love, what more can I add? Should I tell you that I love you, or have you already understood that? Please do answer this please, because here, each new day is like a new thorn in my heart.
Yours forever, Love
Because every day I am thinking of you. Although you are away from me I can still hear your heart beating for me.I can still remember the deepness of your eye that had made me sink in it as it is more than the deepness of the ocean .All that I want to say is that I love you not only today but every day as everyday is aLove day for me.

You stole my heart

Each time I met you, each time I talked to you,
I could not prevent my heart from opening up for you,

To The Depth Of Love

I remembered how I felt about you,
I remembered acting mean and rough...
to keep myself from falling...
falling for you...
and yet...
and yet, I am forever being drawn towards you...
I really can't say why...
I guess it's your freshness, Your easy and warm smile,
The mischievous glint in your eyes, Your delicate and precious body,
The fragile impression coming from you...
I guess it's all that which
Makes me want to come running to you
And squeeze you very hard in my arms...
Tasting your inviting lips and telling you that
I really care a lot for you....
And wish so much to be able to tell you so...

 To tell you to please be by my side…
To tell you that I desperately need you
To assure you that I'll always be there to protect you…

Please hold my hand and walk along with me… On this long road… the road of life…

Each time I taste your kiss and each smile that sweeps across your face feeds the hope in inside me. No other feeling could replace this trembling in my heart.

Awakened by the thought that this is true and all the words you whisper so sweetly. All the love I feel for you, I love you more each minute and each hour of the twenty-four. You are my everything. I wish I could give you more. I give you my heart and it feels safe. I open my world to you, I cccould not see it any other way.

You are in my every thought and a part of every dream. I never thought I have find you. I hope you never leave............

because my love, I feel in heaven when I look in your eyes, you drove me crazy. I love you in the deepest corner in my heart.

When I see you, I seem to withdraw into a quiet madness. Maybe one day my death will tell you how much I love you and that I've always been waiting for you.

My own love's deepest is that of the sea.

Read by you, Written by me, hope you like, what you see. My little Queen.....in
this loving Day, Right here, right now, small is the gift, but big is my heart, filled with the love, you shared from the start. Here is the key, the key to my heart, there you will see, all the Love that I have for you. Nothing in the world, Would make me happier, than to just be with you, Not money, Not flowers, Nor balloons, will ever replace, just being with you. The way you treat me, and the smile you have, just makes me realize, how lucky I am...to be with u my love armelle

Darling, You mean so much to me...
Glorious hours together, sharing our thoughts and desires.There are times when you've trusted me and been forgiving, understanding, there are times so many times when I feel that I owe you much more,and want to give so much in return...
I Love you, just the way I dreamed it would be...

ABOUT THE AUTHOR

L. J. Belamour, Born in a Haiti, Grow up in New Jersey, I been writing a collective of poems since high school. I'm a dreamer, a poet, a lover, a husband, a father, and a man of God. I'm inspired by what I've seen and what I've read, but what I create with my words is where I dream. I pray for inspiration, and I enjoy what I have written just as I hope that others will as well. I'm a quiet man on the outside, but writing has become the playground of my soul to express myself in words. The best way to find out more about me is to read my books. I write from the heart and I express my feelings in this writing. I like to think of my writing as 'Reality Fiction'. I tell it like as I think of it. My writing could be a 'make believe', however I try to live out what I write. I enjoy my work and I hope you do too. Have a blessed time reading my feeling and I hope you feeling the same in the event if you do please share this book with the one you love.

www.ingramcontent.com/pod-product-compliance
Lightning Source LLC
Chambersburg PA
CBHW030908180526
45163CB00004B/1757